HOW TO READ BUILDINGS

An Easy Reference Guide

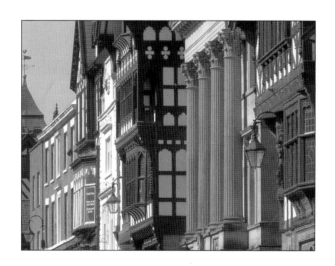

TREVOR YORKE

COUNTRYSIDE BOOKS
NEWBURY BERKSHIRE

Countryside Books
3 Catherine Road
Newbury, Berkshire

To view our complete range of books
please visit us at
www.countrysidebooks.co.uk

ISBN 978 1 84674 343 6

Photographs and cover illustration by Trevor Yorke

Produced by The Letterworks Ltd., Reading
Typeset by KT Designs, St Helens
Printed by The Holywell Press, Oxford

CONTENTS

INTRODUCTION

Our old buildings which proudly stand in Britain's cities, towns and villages are a fascinating link with the past. These structures give our communities a reassuring permanence, an historic value, and evoke an emotional response. From a humble black and white Tudor cottage to a colourful Victorian town hall, their contorted timbers, patterned brickwork or rustic masonry inspire investigation and query. We wonder about the lives of the different people who have walked through their doors over the centuries. We consider what historic events might have been witnessed from their windows. However, the first question before all others can be put in context must be, 'How old is the building?'.

There is lots of crucial information to help in dating an historic building, once you know the clues to look out for. The building's location, its form, the materials used and the type of windows and doors fitted can all help to narrow down the period. By recognising these dateable features, you can then start piecing together its history, understanding how the building has developed over time, and something of the lives of the people who once lived within its walls.

This easy reference guide, with its many photographs and captions, leads you through the various points to examine, in order to narrow down the construction date. There are illustrated examples of some notable buildings, with their background history and the details which help to date them. A glossary helps with any unfamiliar vocabulary.

Soon the buildings around you will no longer be just bricks and mortar. As you learn to read their dateable details, history will come alive. By being able to associate the shape of a roof, the bonding of the bricks, and the moulding above the door with a certain period, you will be able to unlock the past. You can then enjoy the thrill of understanding how their various owners over the centuries, have shaped and altered the house to meet their needs and the changes in architectural fashion.

Trevor Yorke

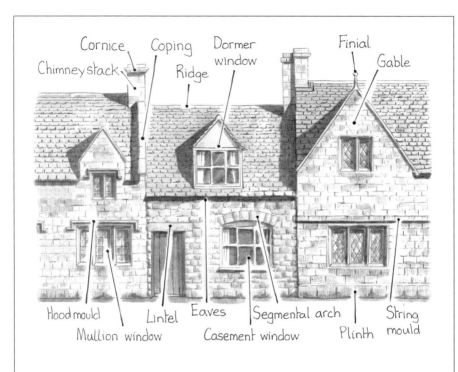

Cornice · Coping · Dormer window · Finial · Gable · Chimney stack · Ridge

Hood mould · Lintel · Eaves · Segmental arch · String mould · Mullion window · Casement window · Plinth

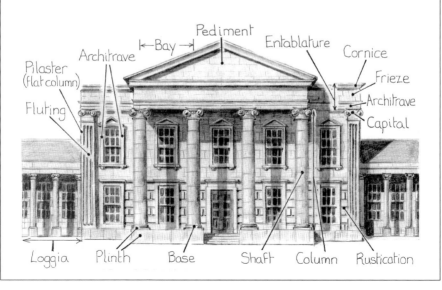

Pilaster (Flat column) · Architrave · ⊢Bay⊣ · Pediment · Entablature · Cornice · Frieze · Architrave · Capital · Fluting

Loggia · Plinth · Base · Shaft · Column · Rustication

5

PREFACE

How To Date Buildings

Britain's old buildings come in all shapes and sizes, constructed from a wide variety of materials and with original details dating back, in a few cases, over a thousand years. While some buildings are vernacular, built by local craftsman in regional styles with materials found close at hand, others were designed by fashionable architects and reflected that period's trends in architecture. Dating a building can be particularly challenging when the builder has borrowed styles from an earlier period, this was particularly the case in the 19th century.

Victorians were heavily influenced by the Gothic architecture of the Medieval period, they also looked to 16th and 17th century buildings for inspiration. The revival styles they created were so close to the original that they can sometimes be hard to tell apart.

To further complicate the matter, an architectural fashion could take up to fifty years to permeate across the country. While builders in important urban locations were under pressure to use the latest styles in order to remain competitive, a builder in a small town may not have felt the same need to change the style they were comfortable with and had used throughout their career. As a result, there can be a difference of many decades between similar style buildings, and this has to be taken into account when dating buildings.

Underlying these sometimes confusing styles, are certain structures and fittings that are unique to a particular period. Decorative details can also help to pinpoint the time of construction and piece together the history of a building. Being able to recognise these details will be the focus of this book.

When studying a building, it is important to work from the whole to the part. In other words, first step back and look at its surroundings, before considering its particular architectural details. Is the street an old route, or one laid out in recent times? Is it close to a railway station, canal or factory, and

FIG 0.1: The ground level *around an old building will tend to rise as gardens are worked and roads have new surfaces added. A doorway approached down steps or a window below ground level can indicate that the building is centuries old.*

hence the building could date from the period when these arrived? Is the ground level of the building lower than the road in front? Assuming the area is flat, then as roads are built up over the centuries this would indicate that the structure is very old. Is the building set upon one of a series of long, narrow plots in the older part of a town? These are medieval land divisions and the present building may have old foundations or a basement.

As you move on to study the building in closer detail, look at the walls for signs of change. A vertical break where the masonry or brick does not line up and is not bonded together, indicates that one period of building had finished and a later one begun. Look to see if the horizontal lines are sagging slightly, or if windows are not neatly lined up. Old timber framed buildings were unfashionable in the Georgian period and were often refaced or covered in render. If possible, look down the sides or rear, as this is where the original

building is often revealed and signs of later extensions and changes will be exposed. This can be key in establishing the development of the building, and which parts are the oldest.

The general condition of the materials it is built from is an invaluable indicator of its age. Worn masonry, crumbling brickwork and weathered timbers show their age, just as sharp-edged walls and clean surfaces appear modern. Although this will often help in dating a building it should not be used as a definite rule. The Victorians were very ruthless when restoring old buildings and cut medieval stone back. Also pollution and frost can make certain materials used by the Victorians now seem centuries old. It is also worth bearing in mind that ruined structures were raided in the past to supply materials for new buildings. The Saxons reused Roman bricks in their churches, while numerous buildings close to old abbeys and castles were constructed with large pieces of masonry taken from these ruins.

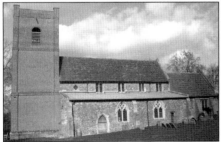 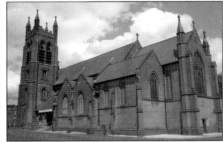

FIG 0.2: The revival of Medieval and Tudor styles *by the Victorians adds to the confusion when dating buildings. The originals tend to show signs of wear, display various stages of building, use different materials and not have features neatly lined up, as shown here in this Suffolk church (left) with a mix of roof and wall materials and styles of windows. The 19th century version will be all of one build and seem more contrived, as here in an example from Birmingham which is characteristically all in brick with an off set tower (right).*

The fittings, like windows, doors and decorative details set into the walls, are useful tools in narrowing down the age of a building. This can be fairly accurate in the 19th and early 20th century, when building regulations were more thoroughly applied. Caution needs to be applied though, as owners in the past were just as keen to update their properties as we are today, and old fittings could have been replaced with the latest sash windows and panelled doors.

This enjoyable detective work will usually have many twists and turns as you study a building. However, if you work though the pointers in this book, you will soon be confident in placing a building within its historic context.

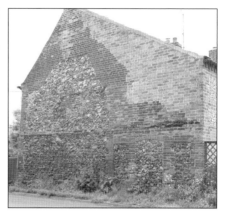

FIG 0.4: Extensions and alterations *are often made over the centuries. Even this modest cottage has been raised in height and then later had a new extension at the rear - a series of changes which are recorded in the different brickwork. These additions are not usually bonded onto the existing structure but are butted up, so look out for vertical lines to mark a later build.*

FIG 0.3: In the Georgian period *it was common to face over old buildings to make them appear more up to date. It therefore pays to look down the side and if possible the rear to see if the front is just a facade. This old building with its distinctive steep pitched roof and buildings running down its narrow urban plot to the left has had a fashionable brick front with sash windows added in the 18th century.*

FIG 0.5: Blocked up windows and doors *can sometimes be seen on the front or side of a building. This example from Suffolk has had its original form reconfigured at a later date in an attempt to make a roughly symmetrical single property. The render or paint which would have completed this renovation has since been removed, revealing the original doorframe and windows.*

WALLS, JETTIES AND TOWERS
How to date the main structure

When looking at a building, there are clues to its age from the way the structure has been designed and constructed. The Saxons and Normans made their stone walls very thick to counter the load from the roof, so their round arched doors and windows were set in deep openings and their buildings tended to be tall and narrow. Masons soon realised that a pointed arch was more flexible than a round, and that by adding buttresses along the walls, the thrust from the roof could be countered. This meant that walls became thinner and windows larger. From the late 12th century, these new ideas resulted in ever more graceful Gothic churches, chapels and halls. Carpenters also developed new methods of building the roof structure with horizontal tie beams and braces which allowed them to span wider spaces without pushing the walls outwards. This culminated in the ingenious hammer beam roof with an open central section, the finest example of which is at Westminster Hall, London, which spans nearly 70ft.

From the late 16th century, the influence of the Renaissance, and an appreciation of Classical architecture, changed the approach to building design. Medieval structures had been asymmetric, with the function of each part shaping its form. Now buildings increasingly became symmetrical, with their shape controlled by mathematical proportions. This evolved into the elegant Classical buildings of the 18th century, with plain walls featuring rectangular windows, columns, and pediments and the roof hidden behind a parapet. Large buildings in the past had been of single room depth, arranged in a row or around a courtyard. From the late 17th century, they became double piled (two rooms deep), with corridors and hallways allowing both access and increased privacy.

FIG 1.1: Most tall urban buildings were built with a rectangular body, as here on the right. But in the 1920s and 30s stepped blocks were a distinctive style for tall structures, as here on the left.

9

In the 19th century, new materials like Welsh slates and cast iron, along with developments in structural engineering, resulted in taller, wider buildings becoming quicker and more economical to build. The Gothic revival encouraged architects to design asymmetrical buildings with prominent, steep pitched roofs and walls filled with colour and pattern.

Towards the end of the century Arts and Crafts architects built houses which embraced the landscape rather than dominating it, with many built down a slope rather than having the site levelled first. Some of their buildings had 'L' shaped plans or were arranged around a courtyard. Buildings with two angled wings flanking the main entrance which formed a 'Y' shaped plan were used on some churches and houses in the early 20th century.

Concrete foundations, steel frames and carefully calculated trusses from the early 20th century permitted ever increasing width and height, and freed the exterior from bearing the load, so it could become just a cladding of glass or metal sheets.

THE MAIN BODY

FIG 1.2: A Medieval building *had its parts shaped by their function, with little concern for its relationship with the other parts (left). Classical buildings had their facade and plan controlled by symmetry and mathematical proportions, derived from ruins in Ancient Rome and Greece (centre). When the Victorians revived Medieval Gothic architecture, they used asymmetry (right) and emphasised the function once again, as shown here by the windows on the tower lighting the steps.*

FIG 1.3: Churches *often had a curved or polygonal apse at the east end in the 11th and 12th century with a tall, narrow body (left). From the 13th to 15th centuries (right) they typically had a square ended chancel (the space reserved for the clergy at the east end) with extra space* 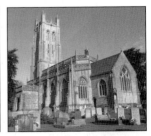 *provided by aisles to the side of a wider nave (the main body of the church for the congregation).*

FIG 1.4: Single and double pile buildings: *Most buildings up until the late 17th century were single piled, built one room deep (left). Larger structures could have this single room depth wrapped around a courtyard, so they appeared grander from the outside (centre). Double pile, two room depth, became standard for most buildings in the 18th century (right), although not for the smallest houses until the late 19th century.*

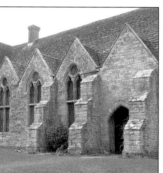 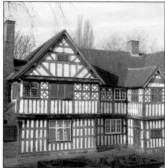

FIG 1.5: Medieval halls *were large open structures with an entrance passage at one end (left). In the 16th and 17th centuries, to gain greater privacy for the owner they were built as two storey structures or had a floor inserted into the old open space to create private chambers above a smaller hall (right).*

FIG 1.6: Victorian terraces *were generally taller than earlier Georgian ones, as ceiling heights rose and additional floors were required. This can even be seen in small terraces where those from the first half of the 19th century had low roofs and windows tucked up tight under the eaves (left), but in the second half of the century they usually had steeper roofs and exposed lintels (right). Note also that these were stepped back from the road as it became desirable to increase privacy.*

 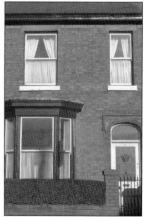

11

FIG 1.7: Symmetrical facades were designed for most buildings from the late 17th century, although some early attempts were often slightly off centre (top left). Strict symmetry and proportions controlled the facades of 18th century buildings (top right). Palace fronted terraces had the centre and each end of the row brought forward and highlighted with columns and pediments, so it appeared like a single grand building. They could be straight or crescent shaped and were fashionable in the late 18th and early 19th century (bottom).

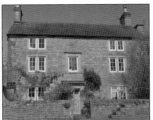
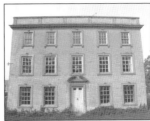

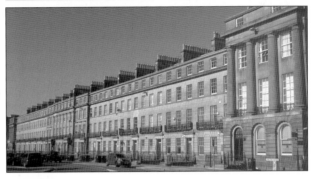

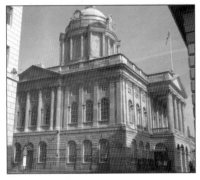

FIG 1.8: The most important room or floor was usually emphasised on the exterior by large windows. The end where the lord of the manor sat in his Medieval hall was often illuminated by a tall window. In the 18th and early 19th century, the first floor or piano nobile had the tallest windows and was raised above a rusticated basement in the grandest buildings (right).

MAKING MORE ROOM

FIG 1.9: Jetties were a practical way of gaining more room and raising the status of an urban building (left), especially in the 15th and 16th centuries. Two jetties flanking a recessed centre, known as a Wealden house, are distinctive of the 15th and early 16th centuries (right).

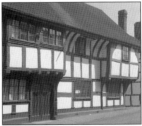

FIG 1.10: Basements *became a common way of providing service rooms in buildings during the 18th and early 19th centuries. At first they were completely below ground (left), but by the late 18th century the upper half of the windows were above ground and the front door accessed up steps (right).*

FIG 1.11: Rear extensions: *Early 19th century small to medium sized terraced housing would have a plain rear, sometimes with an outbuilding like a privy (left). By the mid century, better quality houses had a single storey extension as part of the original build with a scullery, and by the*

last decades a two storey extension with a bedroom above was common (right).

Holt Methodist Church, Norfolk: *Victorian churches can usually be distinguished from Medieval churches by their carefully arranged asymmetrical structure, the use of bricks and the appearance that it is all of one build. This edifice has a polygonal apse which was fashionable when it was built in the early 1860s. The offset turret above the stepped entrance is also distinctive of the late 19th century.*

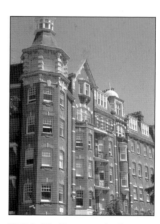

FIG 1.12: Purpose built blocks of flats *were rare before the 1870s. Bold red brick structures (above), often called mansions, were popular in cities from the 1890s-1910s.*

THE TOP OF THE WALL

FIG 1.13: Crenellations *were a defensive feature which remained fashionable into the 16th century (top left) and on late 18th and early 19th century revival styles. Parapets hid the roof from below on Classical buildings. Balustrades with urns were fashionable in the late 17th and early 18th century, mid 19th century Italianate and on Edwardian Baroque buildings (bottom left). Solid parapets were used on most other Classical buildings (top right). A deep overhanging roof with brackets (bottom right) was used on Dutch inspired*

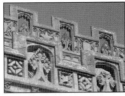
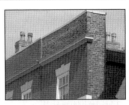
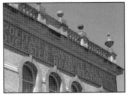
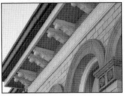

buildings of the late 17th century, and again above Regency and Victorian Italianate walls.

FIG 1.14: A triangular gable end *on narrow urban plots usually faced the road, giving opportunity for decorative timber work on Medieval examples (left). Early 17th century buildings often featured Dutch gables (centre left) which were also revived in the 1830s-50s and 1870s -90s. Late 16th and 17th century gables were often capped by coping stones, balls and finials. Gables from the late 17th century often featured small oval windows (centre right). Gables did not suit most Classical buildings, but were revived again in the 19th century with carved bargeboards (right) typical of Victorian Gothic buildings.*

Constitution Hill, Birmingham: *The Victorians loved squeezing buildings into awkward sites, like this former factory of H.B. Sale in an acute road junction. The rich terracotta décor is typical of the 1890s when it was built.*

TOWERS AND TURRETS

FIG 1.15: Norman castle towers *were generally square in plan (left, with a later ogee shaped roof). As projectiles and tunnelling could topple them, round (centre) and polygonal (right) towers without the vulnerable corners were used on most late 13th and 14th century castles. Machicolations, a line of stone brackets supporting a wall around the top of a tower, was fashionable in the 14th and 15th centuries. As defence became less of an issue by this time so all forms of tower can be found with larger and more numerous windows. 14th and 15th century square planned brick towers are a distinctive feature of East Anglia.*

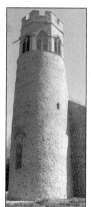 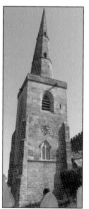 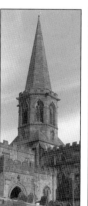 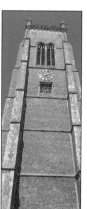 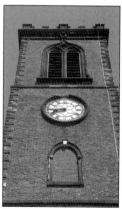

FIG 1.16: Saxon and Norman church towers *were generally squat with thick walls and small openings. Round towers were common in the east, most dating from the 10th and 11th centuries (left). Spires were fashionable on 13th and early 14th century towers (centre left). Central towers were an option on many larger churches and tend to date from the 12th to early 14th centuries, later examples often had octagonal upper sections (centre). Tall towers with prominent buttresses on the west end of the church are distinctive of the late 14th and 15th centuries (centre right). There was considerably less church building in the late 17th and 18th centuries and the few towers erected tended to be plain with round arched openings, no buttresses and some Classical or Gothic revival trimmings (right).*

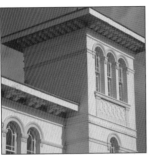 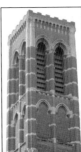

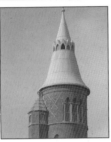 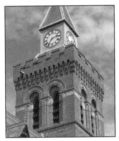 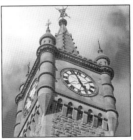 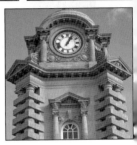

FIG 1.17: Towers are a distinctive feature *of Victorian buildings. Italianate towers with deep bracketed eaves, round arched openings and flat pyramidal roofs were popular in the 1840s and 50s (top left). Gothic style towers had steep pitched roofs (top centre left and centre) from the 1850s-70s. Church towers with coloured brickwork and a Medieval form can also be found in the same period (top centre right). Parisian style pyramidal roofs with a flat top lined by small ironwork crests were fashionable in the 1870s (top right), as were round capped towers (bottom left). Clock towers with crenulations and turrets are common on major buildings from the 1860s-80s (bottom centre left and right). The Baroque style with columns, round arches and domes were revived in the early 1900s (bottom right).*

North Oxford: *The structure of 19th century houses can help narrow the date when they were built, irrespective of their decorative treatment. This example has an asymmetrical facade, a steep pitched roof, tall prominent chimneys and gable ends facing the road - all typical of mid Victorian houses. The single storey bay window, polychromatic brickwork and the Gothic pointed arches narrow it down to the 1860s and 70s. The area to the north of the old colleges in Oxford was redeveloped from the late 1860s, principally in this distinctive Gothic style. This followed the decision to allow college dons to marry, hence requiring a larger home. Many of these houses were also bought by local middle class families.*

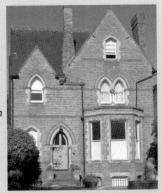

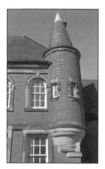

FIG 1.18: Turrets were a feature found on some Medieval and Tudor buildings, especially on the continent, and were revived by the Victorians. They can be found on all types of buildings in the second half of the 19th century, but round ones are especially distinctive of the Scottish baronial style which was popular in the 1870s and 80s.

Former Icknield Street School, Birmingham: *Sometimes an event like a major war or an Act of Parliament can help to date a building. For instance, during the Napoleonic Wars there was a patriotic fever which resulted in the building of mock castles. There were very few new urban churches erected after the reformation of the 1530s, until the Church Building Act 1818 instigated a sudden boom. The Education Act 1870 was the first of a series which resulted in the building of thousands of new brick schools in towns and villages. This former school by J.H. Chamberlain dates from 1883, and was designed with the tower incorporating vents which allowed air to be drawn up to ventilate the main building.*

FIG 1.19: Norman buildings *had very shallow buttresses, virtually flush with the wall. From the 13th century these grew in depth (above top), becoming prominent stepped projections on buildings and towers by the 15th century. Arts and Crafts buildings from the late 19th century had distinctive shallow sloping buttresses (above bottom).*

FIG 1.20: These large shallow, blind arches *across the facade of a building were a popular feature in the Regency period.*

17

BRICKS, MASONRY AND TIMBER FRAMES
How to date the walls

The walls of a building can be a useful tool in determining the age of the structure. The type of material used, the finish and the degree of wear and tear are all important clues. Masonry has always been the most desirable building material, but with the difficulty of quarrying it, the cost of transport and the fact that most skilled masons worked for the Crown or the Church, it was not until the 17th century that its use became widespread. During the 18th and early 19th century, masonry was the dominant building material for most high class buildings.

Bricks had first been used by the Romans but the skills to make them were lost after they left in the 5th century. They were reintroduced in the late 13th century from Holland and Germany via ports like Hull, Kings Lynn and Ipswich and were used for important buildings in these areas where good building stone was sparse. By the 16th century, brick was a fashionable and desirable material and its use had spread to the southern counties and parts of the Midlands. As brickworks became more established, they started to be used for cheaper housing. Its desirability then waned, such that by the mid 18th century brick was often rendered over in stucco to imitate fine masonry. In the mid 19th century, brick became fashionable once again with an explosion of colourful patterns, new high quality products and a railway network which could transport them nationwide.

Timber framing had been the most popular form of walling until fashion and its flammability had limited its use from the mid 17th century. The Victorians revived it with black and white patterns above red brick or masonry lower floors, and this style is distinctive of the later 19th and early 20th century. Despite the outward appearance of medievalism in brick, stone and timber, many large buildings from the 1860s onwards actually relied upon iron, and later steel frames, set in concrete foundations. The iconic Victorian Midland Hotel, St Pancras, was constructed in this way.

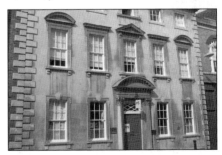

FIG 2.1: Masonry *was the most desirable building material in the 18th and early 19th century and fine jointed blocks and carved details are distinctive of these elegant Classical buildings.*

MASONRY

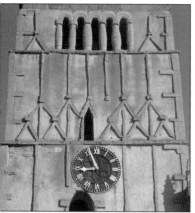

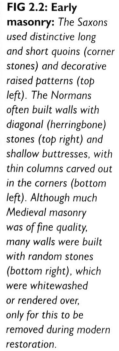

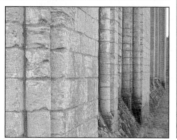

FIG 2.2: Early masonry: *The Saxons used distinctive long and short quoins (corner stones) and decorative raised patterns (top left). The Normans often built walls with diagonal (herringbone) stones (top right) and shallow buttresses, with thin columns carved out in the corners (bottom left). Although much Medieval masonry was of fine quality, many walls were built with random stones (bottom right), which were whitewashed or rendered over, only for this to be removed during modern restoration.*

FIG 2.3: Georgian masonry *(left) had very fine joints and a smooth finish (ashlar). If this could not be attained, then rougher stone or cheaper brick could be covered in stucco (render) and finished to imitate it. The chipped surface on the face of the stones was used to key it (centre). Most of these fine masonry walls were just a cladding, typically reserved for the front elevation, with cheaper materials exposed down the sides and rear. Although the masonry may not easily be datable, the brick used in these locations may be. For instance, the distinctive chequered pattern brickwork (right) is distinctive of the early 19th century.*

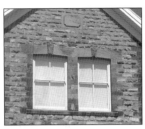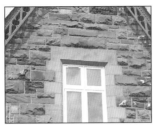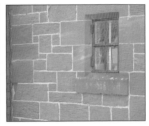

FIG 2.4: Masonry in the second half of the 19th century *was usually machine cut and sharp edged. Leaving the face with a rough hewn rock face was fashionable (left and centre). Squared blocks were normally laid in neat courses (left), but some imitated older walls by using random sized pieces (centre and right). The sharp, plain chamfered opening (right) is distinctive of late 19th century Arts and Crafts style buildings.*

FIG 2.5: Flints *with one face squared off (knapped) were framed by stone (top left) in Medieval flushwork. Flint (top right), a hard chalk called clunch (bottom left) and pebbles (bottom right) were still used in the 18th and 19th centuries where there was a lack of good building stone. Although later work tends to be neatly coursed, the stones themselves are hard to date. It is the bricks used to form the corners which can be key to dating.*

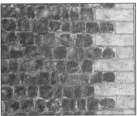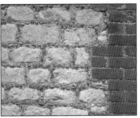

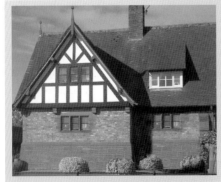

Aldford, Cheshire: *This building has all the charm of an old Tudor structure. However, the combination of timber framing above a brick ground floor with a sandstone plinth was popular in the Victorian period. The steep tiled roof with terracotta ridge tiles and finials, the low bevel edged mullion windows and the sharp edged timbers confirm this date. It was originally a school and adjoining headmaster's house, built in 1872 on the Duke of Westminster's estate, but was converted into private cottages only forty years later.*

BRICK

FIG 2.6: The earliest bricks *dating from the late Medieval and Tudor period tend to be thin and long, with a rough surface reflecting the clay which would have been extracted close to the building site (left). As brick grew in popularity during the 17th century, so local brickworks became established and the size of brick standardized (centre left). By the early 19th century, bricks were uniform in size (centre), although they were still handmade with their colour and finish depending upon the local clay used. A recessed upper and/or lower surface (frog) was introduced from around 1800, although this can only be seen if an individual brick is exposed. From the mid 19th century, new methods of mass production, machine cutting, and improved transport meant finer quality, sharp edged bricks were widely available (centre right). Pressed patterns in the face of bricks were popular from the 1930s (right).*

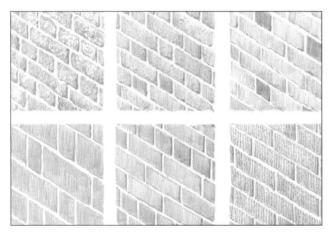

FIG 2.7: Bonding *is the way in which the bricks are laid in the wall and the pattern formed on the outside from the long sides of the bricks (stretchers) and the short ends (headers). Early brick walls usually have no clear pattern. English bond is a row of headers, then one of stretchers (top left) and was developed in the 16th century. Flemish bond has a header followed by a stretcher in each course (top centre), and became standard from the early 18th through to the mid 19th centuries. Both of these could have a number of courses of stretchers inserted so less bricks were used, referred to as a garden bond (top right). Brick tax (1784-1850), which was applied on the quantity used, encouraged manufacturers to make bricks larger and some builders to use rat bond, with the bricks stacked up on their thinner sides (bottom left). English bond was reintroduced in the late 19th century, often in its garden bond version (bottom centre). Stretcher bond, with a cavity between the inner and outer face (bottom right), can be found in the late 19th century and became standard from the 1920s.*

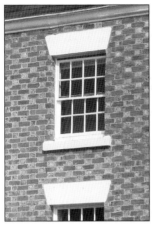 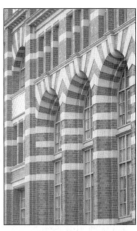

FIG 2.8: Diamond shaped patterns *formed in darker bricks were popular in the 15th and 16th centuries and were reintroduced in many Victorian buildings. Regency brickwork often had chequered patterns formed from red mixed with cream or grey bricks (left). Polychromatic patterns and stripes formed by using red, cream and black bricks are distinctive of the mid 1850s to late 1870s (centre). More restrained bands of red brick and cream stone (right) were fashionable in the late 19th and early 20th centuries.*

FIG 2.9: Pointing *between older worn bricks will usually have been replaced leaving varying widths of mortar (left). In the 18th and 19th centuries very fine gaps between bricks around openings can be found (centre). Tuck pointing, with a fine line scoured in the mortar (right), was common in the 18th and early 19th centuries.*

TIMBER FRAMING

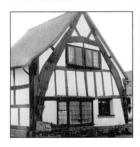 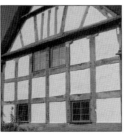

FIG 2.10: Medieval timber framed buildings *could be formed in two ways. Cruck frames were made from a tree trunk split in two to form a triangular frame (left) and tend to be the oldest. Box framing is formed with horizontal and vertical timbers (right), it is much more common and was still used into the 18th century.*

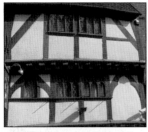
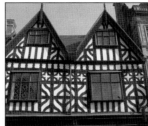
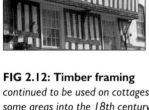
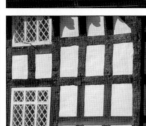

FIG 2.11: Early timber framing *tends to have thick timbers and wide spaces (top left). Patterns were formed in the spaces, especially in high quality work from the late 15th to early 17th centuries (top right). Close studding with tightly packed vertical timbers (bottom left) was popular in this period, particularly in eastern and southern counties, with square panels common in the west (bottom right).*

FIG 2.12: Timber framing *continued to be used on cottages in some areas into the 18th century, but they tend to have thinner and more random sized pieces. The Victorians revived timber framing, with regular sized and straight edged pieces (left), often showing machine saw cuts (right).*

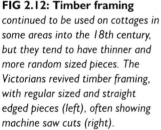
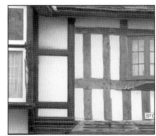
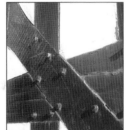

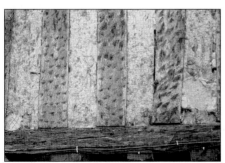

FIG 2.13: Wattle and daub *(a weave of sticks covered in mud and straw) was the most common infill between the timbers, and rough surfaced original work does still survive. Some of these were later covered all over in render with distinctive chips made in the timbers as a key (top left). Wattle and daub was often replaced with bricks (nogging) at a later date (right).*

THE TOP OF THE WALL

FIG 2.14: Cast iron *was used for columns and brackets in industrial and commercial buildings from the turn of the 19th century, but was usually hidden behind brick or masonry. The new railways pioneered its use for station canopies and large glass and iron train sheds, with columns featuring decorative cast iron capitals. In the late 19th century, iron frames with large sheets of glass formed daringly modern facades, especially for shop fronts (left).*

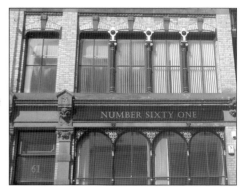

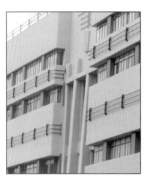

FIG 2.15: The Romans invented concrete *from a mix of cement and aggregate. However, it was not until the 19th century that it was reinvented and used in buildings. The Victorians began making foundations out of this material, although this was not common practice until the early 20th century. They even built a few houses out of concrete. From the late 1920s, concrete was used for Art Deco and Modernist buildings (left). A lot of these smooth white walls were actually made from brick with a cement rendering. Genuine concrete structures will have rough horizontal lines showing between the layers.*

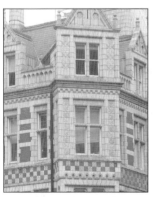
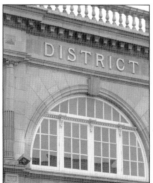

FIG 2.16: In the late 19th century, *important buildings could be clad in red and buff terracotta tiling (left and centre), while white glazed tiles sometimes with bright green trimming were popular in the 1920s and 30s (right).*

FIG 2.17: Hanging tiles *were used to cover up timber frames from the 17th century, until brick became widely available. Mathematical tiles were used in the 18th and early 19th century and were moulded so they left a brick shape and could make a convincing looking brick wall. Hanging tiles were revived by the Victorians and were popular on upper storeys in the late 19th and early 20th centuries, with distinctive horizontal bands of different profile tiles (left).*

FIG 2.18: Rendering: *Many medieval stone buildings had roughly composed walls which were originally covered in render (left). In the 18th century, old Gothic buildings were rendered to match the fashionable Classical buildings. Patterns formed in the plaster (pargeting) were popular in East Anglia during the 16th and 17th century. Most found today though will be more recent work (right).*

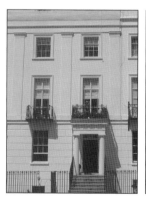

FIG 2.19: Stucco was used *from the late 18th to the mid 19th century as an external smooth render. It was used to cover cheap brickwork, to make it appear like masonry on Classical style (left) and Gothic revival (right) buildings. It could be scoured to form masonry patterns and would originally have been a stone colour.*

FIG 2.20: Roughcast and pebbledash *are traditional coverings that were revived in the late 19th century. They are usually found covering the upper stories of brick and stone buildings from the 1890s to 1930s. Pebbledash had stones applied to the final coat of render (left), roughcast had fine stones mixed into it (right).*

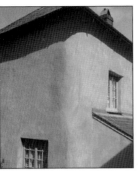

FIG 2.21: Mud mixed with other materials like straw was used to form walls (right) and can still be found in Devon (cob), Buckinghamshire (witchert) and parts of East Anglia. It can have distinctive rounded corners and deep overhanging roofs (left). It is hard to date, although later types revived in the late 19th and early 20th centuries were made using blocks rather than horizontal layers, which can be seen through the outer coating.

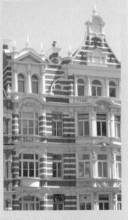

Sloane Square, London: Buildings like this which combine so many elements from different styles and periods can be hard to date, but the striking use of horizontal bands of stone and brick is clearly late Victorian. It was built in 1895 with fashionable Dutch gable and segmental arched windows. The square was laid out in 1771 and named after the owner of the estate, Sir Hans Sloane.

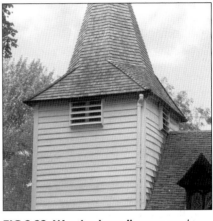

FIG 2.22: Weatherboarding was used to cover old timber frames and cheaper houses, especially during the brick tax years. Most will probably be 18th or 19th century, but the building beneath could be older.

Falsgrave Road, Scarborough: Smooth finished, stucco covered old buildings will probably date to the Regency or early Victorian periods. The prominent pair of bows with thin glazing bars in the sash windows, the French doors on the first floor and the Greek Doric columns were all fashionable in the Regency period, while the rectangular fanlight above the door, the portico and the architraves around the windows point to Victorian influences. Hence, it is believed to date from the 1830s.

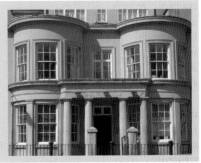

SLATES, TILES AND CHIMNEYS
How to date the roof

An observation of the roof, both the angle it is set at (the pitch) and the type of material covering it, can all help in dating a building. Technological limitations and architectural styles have made certain types of roof distinctive to a period, while the rain shedding properties and weight of slates, tiles and thatch have determined how steep an angle they are set at. Although most old buildings will have had the covering material replaced, the pitch of the roof usually remains unaltered.

Thatch was once the most common roofing material, and required a distinctive steep angled pitch to ensure rain flowed off it. Lead was used for a very shallow angled roof, but due to its great expense, was limited to premium buildings. It can be found hidden behind the parapets of many 14th and 15th century churches. From the 17th century, thatch fell from favour in urban areas, chiefly due to its fire risk. Handmade clay tiles and local stone slates started to replace thatched roofs, and they could be set at a slightly less steeped pitch.

As larger buildings increased in depth in the 17th century, the initial solution was simply to form the roof in a rectangular ring on the largest structures (FIG 1.4. centre), or have two separate roofs side by side (FIG 1.2. centre). From the late 18th century, the improved availability of lightweight and smooth Welsh slates, which could be set at a much lower angle, allowed more flexibility in roofing. This made it easier to hide the roof behind a parapet on the fashionable Classical styled buildings. By the early 19th century, shallow hipped roofs with deep overhangs above the walls became a distinctive feature of the Regency period.

The Victorians' adoption of the Gothic, suited a style of steeper pitched roofs and spires. Although slate was used at first, the Victorians also began the mass production of machine cut clay tiles, with distinctive bands of

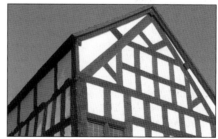

FIG 3.1: When a roof is covered *in a new material, the pitch is usually kept the same due to the costs of rebuilding the timber roof structure. In some old houses though the pitch was altered to gain extra height in the upstairs rooms. This can be revealed by looking at the gable end, as in this timber framed example.*

different profiles and colours. These became fashionable from the 1860s and largely replaced slate on most buildings by the early 20th century. Improved understanding of how roof trusses work and the mass production of materials like iron, steel and glass also made it easier from the second half of the 19th century to span larger spaces, without so many supports required beneath. Concrete or timber covered in layers of bitumen felt made flat roofs (they are actually slightly pitched) a feature of modern style buildings in the 1920s and 30s, although our wet climate has since dampened enthusiasm for them.

ROOFS AND THEIR DETAILS

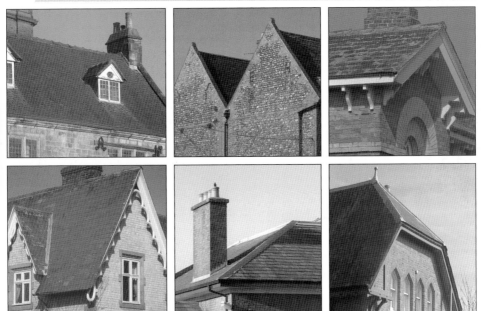

FIG 3.2: The most common form of roof is a pitched or gable roof, with two sloping sides and a gable wall at each end (top left). Most buildings prior to the 17th century were covered this way. Double pile buildings from the late 17th and early 18th centuries were often covered by two parallel pitched roofs (top centre). Regency and Italianate style buildings from the first half of the 19th century had distinctive low pitched roofs, with deep overhangs above the wall supported on brackets (top right). Gothic style buildings from the mid 19th century had steep roofs (bottom left), but they became less so by the 1880s. Richly carved bargeboards around the edges of the gables are distinctive of this period. Hipped roofs which slope on all four sides can be found from the late 17th century. Shallow pitched slate hipped roofs were very popular in the early 19th century (bottom centre), and steeper versions covered in clay tiles were fashionable in the early to mid 20th century. A half hipped roof with the end slope cut short (bottom right) can be found in the same period as hipped, and were a distinctive feature of Gothic buildings in the 1860s.

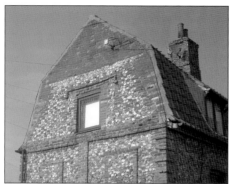

FIG 3.3: Mansard roofs *are double sloped with a very steep lower section punctuated by windows, which make the roof space habitable. They were named after the French architect François Mansart who popularised the form in the early 17th century, but they were not common here until the 19th century when they helped to create bedroom space for servants in urban terraces. This rural example would appear to have been built at a later date in place of an earlier gable roof.*

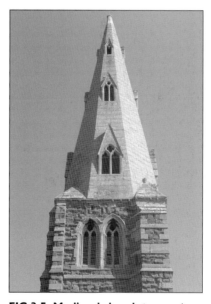

FIG 3.4: Towers *in the late 16th and early 17th centuries were often capped off by distinctive ogee shaped roofs (top left), which resemble the top half of an onion (these were revived in the 1830s and 40s). Late 17th century Baroque buildings featured domes rather than towers, while 18th century Classical buildings rarely had towers. Round and square planned towers with shallow pitched pyramidal roofs were occasionally attached to Regency buildings, a feature that gained in popularity in the first half of the 19th century, as the Victorians loved this feature (top centre). By the late 1850s, steeper versions suited the new Gothic revival style. In the 1870s and 80s, French Empire style roofs (top right and bottom left) were fashionable. Domes became popular on many commercial and public buildings (bottom right) in the early 20th century.*

FIG 3.5: Medieval church towers *in the 13th and 14th centuries often had the addition of a spire. Broach spires (above) were an early favourite, especially in the eastern counties. Later spires tended to be taller and thinner with crockets (small horn shaped projections) up the corners and a parapet around the base. The style of the ventilation holes (spire lights) can help date them (see windows) and smaller ones tend to be later.*

FIG 3.6: Stone slates (left) are a traditional material fitted with the smaller, thinner pieces along the ridge and heavier thicker ones above the wall (as it can better support the weight). They are hard to date as old buildings could have new slates and more recent buildings might be covered with old reused ones. Thin, lightweight Welsh slates (right) became widely available from the late 18th century and can be set at a much shallower angle. Some former steep pitched roofs were rebuilt with a shallow gable then covered in Welsh slates.

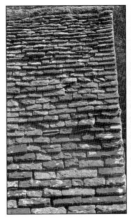
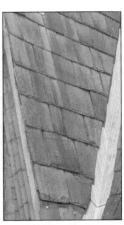

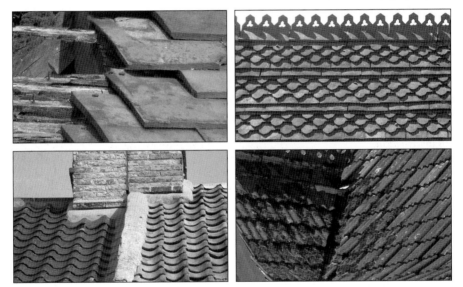

FIG 3.7: Plain clay tiles were manufactured in the same areas as brick, and also grew in popularity during the 17th century. They fell from favour from the late 18th century as lighter slates became available. Machine made clay tiles (top left) were introduced in the mid 19th century, often with bands of different profiles (top right) distinctive of the 1860s and 70s. By the early 20th century, plain clay tiles had replaced slate as the fashionable roof covering. Pantiles are clay tiles with a wave shape which allows them to interlock (bottom left). They date back to Medieval times, although they became popular in the eastern counties and coastal regions from the 17th century until the 19th century. Variations of these, with flat sections or multiple ribs, were produced in the early 20th century (bottom right).

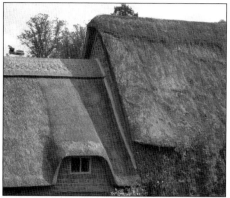

FIG 3.8: Thatching *is the oldest form of roofing and was widely used, even in urban areas, up to the 17th century, and on cottages into the early 19th century. Thatch was revived in some Victorian model villages and by later Arts and Crafts architects. As it is usually partially or fully relaid every 50 to 100 years, it is not possible to date it from appearance alone. Its most distinctive feature is the steep slope it needs to be set at and many old rural houses with clay tiled or slate roofs at an overly steep angle may have formerly been thatched and older than they first appear.*

FIG 3.9: Roof details: *Thin metal arched brackets under the eaves were popular on Arts and Crafts buildings from the late 19th century (top left). Decorative red terracotta or clay ridge tiles were fashionable from the 1850s to 70s (top right and bottom left). Metalwork crests are distinctive of the 1870s and 80s (bottom right).*

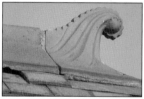

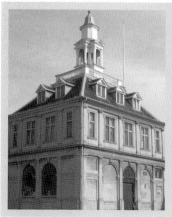

Custom House, King's Lynn: *When the monarchy was restored in 1660, the new king, Charles II, who had spent his exile in the Low Countries, brought with him a taste for Classical architecture in the Dutch style. Hipped roofs with white dormer windows topped off by a balustrade and a cupola or lantern were distinctive of this Dutch influence during the late 17th century. This elegantly proportioned building, with this distinctive type of roof, would seem to date from this period. This is backed up by its symmetrical facades, round arched openings along the ground floor, and first floor cross windows with the transom (horizontal bar) set high within the window. It actually dates from 1683, with its upper floor used for collecting customs and the lower floor originally open for merchants to trade.*

31

CHIMNEYS

FIG 3.10: Chimney position: *A stocky, centrally positioned chimney stack built from old bricks is distinctive of the 17th century (left). Most chimneys are fitted either as part of the outer walls, or emerge along the ridge. But in the Edwardian period there was a fashion for them to be set halfway down the slope (right).*

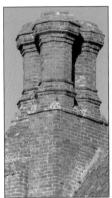
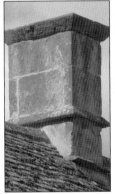
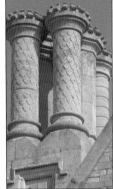
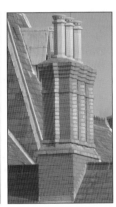

FIG 3.11: Chimneys *were fitted to some major medieval buildings, however they became more standard from the 16th century. They were a status symbol and hence were elaborate with numerous tall chimneys paired or grouped together (top left). From the second half of the 17th century they became plainer and rectangular in form (centre left). Elizabethan style chimneys were revived in the early and mid 19th century (centre right), usually with sharp cut bricks and stonework. Chimneys became a prominent feature once again in the Victorian period, featuring decorative and stepped brickwork (top right). Massive decorative brick stacks were popular from the 1870s to the 1890s (bottom left) with vertical bands emphasising the height. In the 1920s and 30s, chimneys became simpler in design often with a line of vertically stacked bricks around the crest (bottom right).*

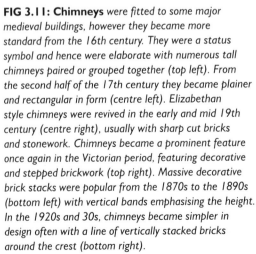
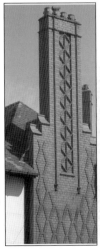
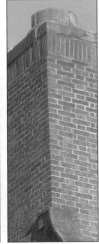

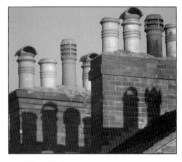

FIG 3.12: Chimney pots: Chimneys need to finish above the ridge of the roof in order to get sufficient draw. By making them higher and with a narrow opening the draw was improved. Hence Victorians developed a wide range of clay and terracotta chimney pots which could be added on top of the flue to make fires burn more efficiently. Although they are a distinctive feature of Victorian buildings, they were also added to older chimneys so caution should be taken in assuming they indicate the chimney is 19th century.

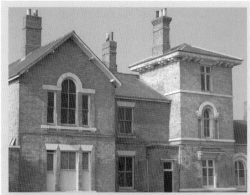

Spalding Station, Lincolnshire: Shallow pitched roofs with brackets under the eaves are very distinctive of early to mid 19th century buildings. However, the asymmetrical form, prominent chimneys, and four pane sash windows on this example help pin point it to the later date. Railway stations needed to be both fashionable and reassuring, to reassure wary passengers that this new technology was both safe and permanent. Hence stations like Spalding were lavish and traditional, in this case built in an Italianate style in 1848 for the Great Northern Railway.

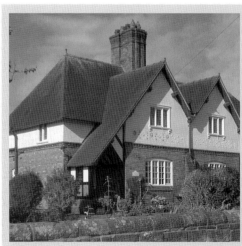

Aldford, Cheshire: Roofs can be very telling of a building's age. Although at a quick glance the structure of this example resembles those of an old cottage, the large hipped roof with true timbers covering a double pile structure is distinctive of the early 20th century. Its prominent decorative chimney, the rendered upper storey, low arched ground floor windows and deep set porch can be found on other buildings influenced by the Arts and Crafts movement from the 1890s. Aldford is an estate village with most houses like this built for the 1st Duke of Westminster in the late 19th century.

SASHES, CASEMENTS AND TRACERY

How to date the windows

Windows are an important tool in dating houses as they have distinct forms which can sometimes be pinpointed to a narrow time slot. Changing fashions, building regulations and technical improvements in the production of glass have affected the way in which they are designed and fitted within the walls. However, owners in the past have been just as keen to update their windows as we are today, so establishing the date of the glazing may tell you when there was a fashionable makeover of the building, but not when it was originally built.

Medieval buildings were built with windows that were open to the elements. They were divided up by vertical mullions, which provided security and strength, with shutters or cloth to keep out the draughts. Only the finest buildings, like churches, had glass from an early date, with the openings becoming larger as walls became thinner. By the 16th century, glass was common, but due to the limitations of the production process, individual pieces were small and had to be held in place by a framework of lead strips. Larger panes of glass would become available for those who could afford them by the 18th century, but it would not be until improved technology from

the mid 19th century that large sheets became widely available.

The simple mullion windows of the 16th century, which could be found in ever more splendid rows of sparkling glass, were superseded by taller cross windows in the second half of the 17th century. Vertical sliding sash windows dominated the 18th and 19th century. Iron frames and glazing bars were available from the late 18th century,

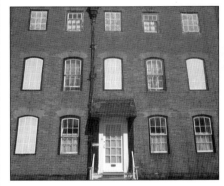

FIG 4.1: Window tax *was introduced in 1696 as a form of income tax and was calculated on the number of windows in a property. It was first charged on buildings with 10 or more windows, then 7 or more from 1766, and 8 from 1825. To avoid paying, some owners bricked up old windows or built new properties with bricked openings to maintain symmetry. The blocked windows in this property have been painted to look like windows. The tax was repealed in 1851.*

and can be found on many public and commercial buildings. Side hinged casement windows, which had been limited to cheaper housing, became popular from the late 19th century, and generally replaced sash windows after the First World War.

MEDIEVAL AND TUDOR

FIG 4.2: Medieval windows: *Saxon windows (top left) had simple round arched openings, some were paired with crude columns. Norman windows (top centre) tend to be more refined. Pointed arches appear in late 12th century, and triple lancet windows (top right) are distinctive of the first half of the 13th century. When tracery, the stone patterned divisions, were introduced in the second half of the 13th century pointed arches were still steep (bottom left). Ogee arches, which curve in and then out (bottom centre), are distinctive of the 14th century. Window arches became shallower in the 15th century (bottom right), and virtually flat by the 16th century.*

 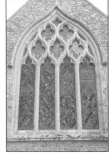

FIG 4.3: Tracery: *Plate tracery (top left) is distinctive of the late 13th century. Decorative tracery with intersecting elaborate patterns was used in early 14th century (top centre). Vertical tracery using the full height of the window distinguishes the perpendicular of the late 14th and 15th century (top right). Victorian tracery can be very similar to the Medieval, but in the 1840s and 50s it was often flush with the wall (bottom left) or stylised (bottom centre). Polished marble columns are distinctive of the 1860s (bottom right).*

 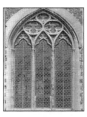 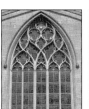 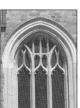 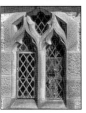 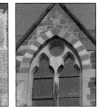 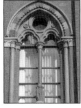

FIG 4.4: Mullion windows are a simple opening divided up by vertical bars. They were the most common window on Medieval and Tudor buildings. On the earliest examples, the mullions are close set as they were not originally glazed (top left). By the 16th and early 17th century, they had wider openings with diamond shaped pieces of leaded glass and

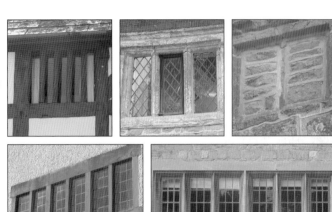

a hood mould above on stone and brick buildings (top centre). The mullions tend to be set at 45 degrees so they were diamond shaped in plan. By the late 17th century they were only used for less important windows down the sides or rear of buildings, except in stone areas like the Cotswolds and Pennines where their use continued into the 18th century. Older ones were often blocked up (top right) and replaced by larger windows. Mullion windows were revived in the late 19th century on Arts and Crafts buildings, distinguished by long rows with sharp edges and rectangular leaded glass (bottom left and right).

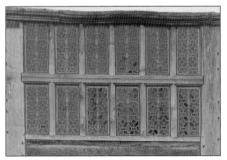
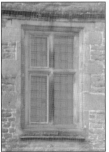
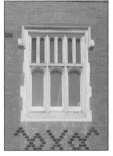

FIG 4.5: Transom and cross windows: On larger Medieval and Tudor windows a horizontal bar, or transom, was added (left). Very long, spectacular examples were fashionable in the late 16th and early 17th century. From the mid 17th to the early 18th century, a tall rectangular form with four lights (the openings between the bars) called a cross window was fashionable (centre). The transom tends to be near the centre in earlier types, and closer to the top in later examples. Mullion and transom windows were revived by the Victorians, especially in the 1840s, and sometimes feature a more inventive arrangements of bars (right).

GEORGIAN AND VICTORIAN

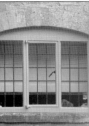
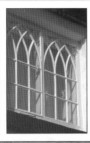
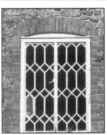
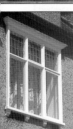

FIG 4.6: A casement *is a hinged frame and could be found within mullion and transom windows. Casement windows as a complete timber frame became common on smaller houses and cottages in the 18th century, often with shallow arches above (top left). Many Regency Gothic types had intersecting pointed arches, or 'Y' shaped bars (top centre). Early and mid 19th century iron casements were common in cottages, with busy geometric or diamond patterns (top right). Larger casements with a tall lower section and a short upper, often filled with coloured glass patterns, became popular from the late 19th century and into the 1930s. Edwardian casements often projected out from the wall (bottom left). Replicas of 18th century cottage style casements were popular on Arts and Crafts inspired buildings around the same time (bottom centre). Metal framed windows, with strong horizontal divisions, are distinctive of the 1930s (bottom right).*

Burford, Oxfordshire: *This distinctive building fronts the High Street in this famous Cotswold town. It is dominated by the tall cross windows, capped by alternate triangular and segmental arched features. Their style, with oval panels, raised quoins and the transom of the cross windows being positioned above centre, would indicate late 17th century. The building is the east wing of the old vicarage and was built in 1672, possibly designed by Christopher Kempster, who was Sir Christopher Wren's master mason while working on St Paul's Cathedral.*

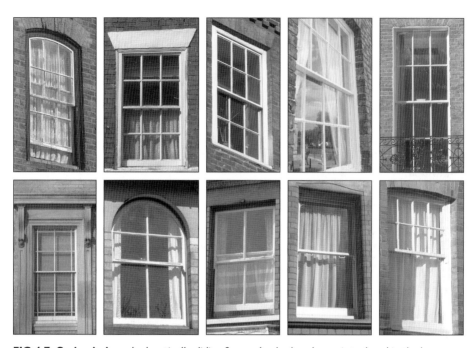

FIG 4.7: Sash windows *had vertically sliding frames (sashes) and were introduced in the late 17th century. Early 18th century examples often have a shallow arched head (top left). Initially, the outer frame which contained the pulleys was exposed and flush with the wall (top centre left), but in the early to mid 18th century they were set slightly back (top centre). From the 1770s the frame was usually set behind the wall (top centre right). The individual panes became larger and the glazing bars thinner, making Regency windows more graceful (top right). Early and mid Victorian sashes often had a thin border around the sashes (bottom left), and round arched types (bottom centre left) were popular in the 1840s and 50s. Larger pieces of glass meant that by the mid 19th century, four light windows (bottom centre) were common, and then two light windows in the later 19th century (bottom centre right). Sashes in the 1890s and 1900s often had the upper sash divided up with glazing bars (bottom right).*

Ashbourne, Derbyshire: *This hall has elements of 16th century timber framing and late 17th century Dutch style, but when all these different forms and materials are put together it dates from the late 19th to early 20th century. The round and semi circular windows and dormers with heart shapes in the glass were also popular in the Edwardian period.*

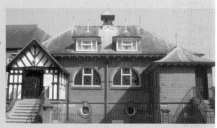

OTHER WINDOWS

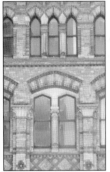
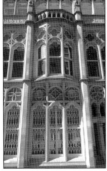

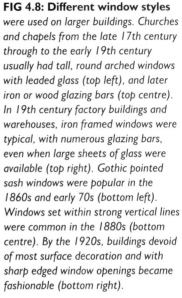

FIG 4.8: Different window styles were used on larger buildings. Churches and chapels from the late 17th century through to the early 19th century usually had tall, round arched windows with leaded glass (top left), and later iron or wood glazing bars (top centre). In 19th century factory buildings and warehouses, iron framed windows were typical, with numerous glazing bars, even when large sheets of glass were available (top right). Gothic pointed sash windows were popular in the 1860s and early 70s (bottom left). Windows set within strong vertical lines were common in the 1880s (bottom centre). By the 1920s, buildings devoid of most surface decoration and with sharp edged window openings became fashionable (bottom right).

FIG 4.9: Dormer windows set in the roof were a distinctive part of late 17th century buildings (left). They continued to be a feature of many cottages in the 18th and 19th century (right) and were particularly popular on Victorian houses. They are best dated from the style of the window and decorative details like bargeboards.

39

Leamington Spa, Warwickshire: *Stucco covered buildings with Gothic pointed arches, hood moulds above the openings and parapets along the top of the gable are distinctive of the Regency period. They were inspired chiefly by Horace Walpole's Strawberry Hill, a gleaming white experiment in the Gothic revival from the 1750s and 60s. Houses like this example can be found in spa towns and seaside resorts, which were developed in the late 18th and early 19th centuries.*

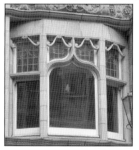

FIG 4.10: Window styles *have changed over time. Small oval windows were fashionable in the late 17th and early 18th century (top left). Ogee arched windows with intersecting glazing bars (top centre) are distinctive of Gothic buildings from the mid to late 18th century. Venetian windows with an arched central sash (top right) can be found in many periods, but were particularly popular in the 18th century. Windows which are wider at the base than at the top (bottom left) were inspired by the discovery of Ancient Egypt in the early 19th century. Windows with curved and sinuous glazing bars are distinctive of Art Nouveau from the first decade of the 20th century (bottom centre). Large half moon (lunette) windows can be found on some 18th century Classical buildings. Both lunette and small round windows were popular in the Edwardian period (bottom right).*

 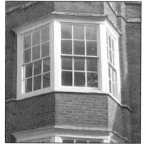 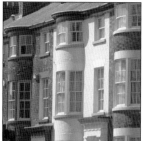

 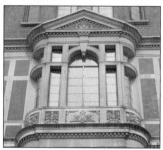

FIG 4.11: Bay and Bow windows: *Rectangular bay windows can be found on many large buildings from the late 16th to early 18th century (top left). Angled or canted bays became popular in the 1750s and 60s (top centre), with semi circular and bow windows with a shallow curved plan becoming fashionable in the late 18th and early 19th century (top right). Bay windows became something of a status symbol on Victorian buildings. In terraced housing, single storey bays were common in the mid 19th century (bottom left) and two storey bays common from the 1870s (bottom centre). Elaborately carved bays with curved ends were fashionable in the late 19th century (bottom right), with semi circular and bow windows returning to fashion in the 1920s, most notably on suburban semi detached houses.*

FIG 4.12: Oriel windows *project from an upper floor. They are a distinctive feature of late Medieval and 16th century buildings. They were revived by the Victorians especially on Gothic revival buildings from the 1860s and 70s. These 19th century versions are distinguished by the sharp, elaborate carving and columns flanking the windows (left).*

GLASS

FIG 4.13: Most medieval stained glass windows *were smashed during the late 16th and early 17th century. Some were reset later in random, fragmented patterns (left). The Victorians revived the art of stained glass and most today will*

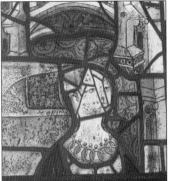
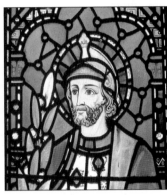

date from the second half of the 19th and early 20th century (right), much of it produced for the restoration of old Medieval windows.

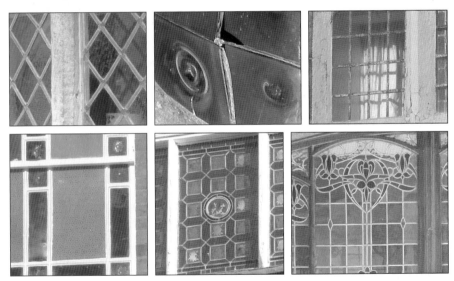

FIG 4.14: Early glass *has an uneven surface, with bubbles within and a slight green or yellow tinge. It was usually cut into diamond shapes (top left). Bulls eyes were only occasionally used in less important windows (top centre), and in most cases those found today are 20th century imitations. Rectangular leaded glass became common from the late 17th century (top right), and was revived in the late 19th and early 20th century. Coloured glass margins (bottom left) and patterns with designs and emblems (bottom centre) were popular in the mid and late 19th century. Coloured glass patterns featuring flowers and ribbons set in rectangular leaded glass (bottom right) is distinctive of Edwardian windows, with more geometric designs popular in the 1930s.*

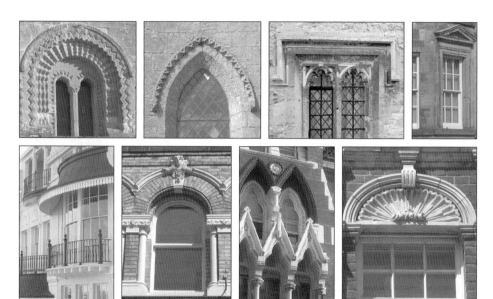

FIG 4.15: Window surrounds *have often been highlighted by decorative or practical features. In the 12th century arched openings sometimes had bands of zig zags around them (top left). In the 13th century a distinctive dog tooth design was popular around pointed arches (top centre left). Above Medieval and 16th century windows, a hood mould was added to direct the rain away from the opening (top centre right). These were replaced from the mid 17th century by a continuous string mould running across the front of a building. Plain surrounds identify 18th century Classical buildings, although key windows could be highlighted by an architrave and pediment (top right). These could be found around all windows in Victorian Classical facades. Regency windows often featured iron balconies and convex hoods (bottom left). Important Victorian windows were often highlighted by flanking columns (bottom centre left). Gothic revival windows could have a carved hood above them in the 1860s and 70s (bottom centre right). Arched shell like hoods based on early 18th century designs were revived in the 1880s and 90s (bottom right).*

DETAILS

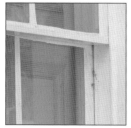

FIG 4.16: Horns: *The glazing bars in sash windows helped keep the frame rigid and true (left). As glazing bars became obsolete, with larger panes of glass from the 1840s, the joint at the bottom of the upper sash had to be strengthened with a short projection coming down from it called a horn (right).*

43

FIG 4.17: External shutters *were sometimes fitted to urban properties in the 18th and early 19th century. The metal pintle (left) on which they were hung and the stay (right) which held them open can still be found and can indicate a genuine house from this period. Most shutters you see today fixed to the front of old houses are more recent additions.*

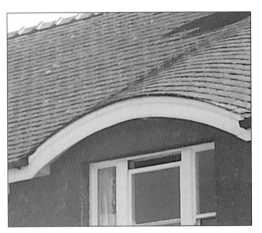

FIG 4.18: A shallow arch *in the eaves above a window is a distinctive feature that was popular in the late 19th and early 20th centuries.*

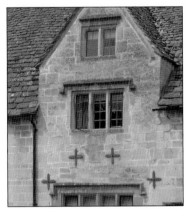

FIG 4.19: A gable end or gabled facade *with a two, three and four light mullion window stacked vertically was popular in the 17th century.*

Hamilton Square, Birkenhead: *Classical styled terraces can be hard to date due to their similarity of form. It tends to be in the details, especially the windows, that the period can be pinpointed. The sash windows in this example have relatively thin glazing bars, large panes of glass and are set behind the stone facing, which indicates the early 19th century. This corresponds with the arched windows along the ground floor, architraves around the upper ones and the ironwork balconies. The semi circular shaped fanlights are also Regency in style, although the clear glass and flat roofed portico over the doors are more typical of the early Victorian period. This square was begun in 1825 for the shipbuilder William Laird, who intended the development to rival Edinburgh and named it after his wife's maiden name.*

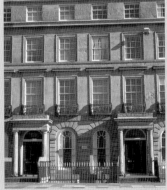

DOORS, PORCHES AND FANLIGHTS
How to date the entrance

The position of the entrance to a building, and the form it takes, has changed over the centuries and can be another useful clue to its age. The door on most Medieval halls and houses opened onto a cross passage. This was originally positioned at one end of the structure, although later extensions may mean it now appears more central. From the late 16th century, symmetry began to influence design and many major buildings had a grand doorway or porch in the middle of the facade - a fashion which had become standard by the second half of the 17th century.

The basement of most major buildings in the 17th century was still fully underground, with the entrance roughly level with the road. However, during the 18th century, half basements became fashionable. They allowed more light into these subterranean service rooms and meant that the door could be positioned up a short flight of steps, making for a more imposing entrance.

In a Medieval building the owner would share the entrance with his household. But as the social ladder took on a more regimented form, by the 18th century a gentleman would insist upon a separate doorway for his servants. A narrow well down which servants could access the basement became a standard feature. As the Victorians sought greater

privacy, the facade was set further back behind a front garden with the door at one end of a path.

On a narrow urban plot, the door was usually set to one side to access the passage or hallway leading to the rear of the building, leaving a single large room at the front. This plan was retained when terraced housing began to

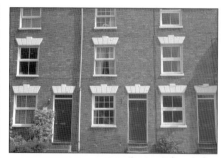

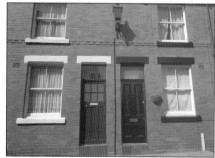

FIG 5.1: Doors were set *on most terraces at the same side on each property (top), but during the second half of the 19th century they were more usually paired (bottom).*

45

dominate the housing stock during the 18th and 19th centuries, although the floors above had symmetrical windows. The door was on the same side of the facade as its neighbours on most 18th century and early 19th century terraces, but in the second half of the Victorian period they were more often set in pairs along the row of houses. When semi detached housing became a popular form in the late 19th century, the doors were usually paired in the centre, but from the 1920s when semi detached became the dominant housing type, most builders positioned them at each end to maximise privacy.

DOORWAYS AND PORCHES

FIG 5.2: Doorways: *Norman doorways were round arches with important examples having decorative bands (top left). In the 13th and 14th centuries doorways with a steep pointed arch and a hood mould (top centre) were common, while in the latter period ogee arches became popular (top right). Doorways in the 15th and early 16th centuries had shallower arches, some with the triangular corners (spandrels) featuring patterns (bottom left). By the late 16th and early 17th centuries square headed (bottom centre) and round arched doorways were fashionable. There are also many distinct vernacular styles from the 17th century (bottom right).*

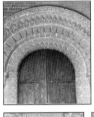
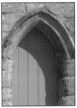
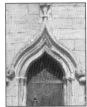
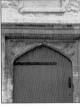
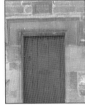

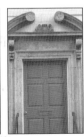
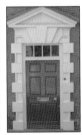
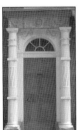
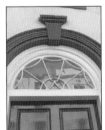
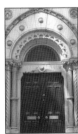

FIG 5.3: Doorcases: *Bolection moulding, which recedes back from the edge of the door (far left), is distinctive of the late 17th century. Pedimented doorcases are common on important entrances throughout the 18th century and early 19th century. Early examples sometimes had a broken pediment (second from left). Gibbs surround (third from left) were fashionable in the mid 18th century. Later examples might have delicate decoration (fourth from left). Reeded doorcases (second from right) were popular in the early 19th century, rectangular ones with round bulls eyes in the corners. Victorian Gothic doorways incorporated pointed arches, some with marble columns and foliage capitals (far right).*

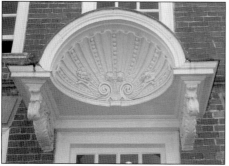

FIG 5.4: Carved scalloped hoods mounted on scrolled brackets are a distinctive feature of many grand town houses from the late 17th and early 18th centuries. The form was also revived in the late Victorian and Edwardian period on Queen Anne style houses, although these tend to be sharp edged and less substantial.

FIG 5.5: Porches: Since Medieval times structures have been added in front of a doorway to keep out draughts, protect visitors and create a more imposing entrance. They were a common addition to churches, especially in the 14th and 15th centuries (top left). Tall porches with a gable on top are distinctive of late 16th and early 17th century buildings (top centre). They did not suit Classical style buildings, but were readily revived in the 19th century on Regency Gothic (top right) and Victorian Gothic (bottom left) dwellings. In the Edwardian period, deep set porches under a large brick arch (bottom centre) and white painted timber porches (bottom right) were fashionable.

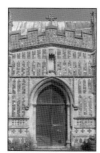
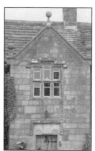
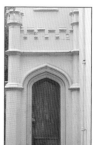
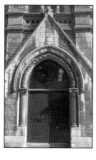
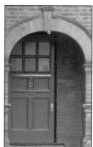
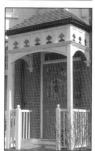

Greenwich, London: Semi detached houses and villas linked by low entrance porches set back from the front are distinctive of early 19th century urban developments. These examples from South London have also retained their distinctive Regency thin glazing bars in the sash windows and the semi circular fan lights above the doors.

47

FIG 5.6: Pedimented fronts and porticos *added a grand touch to the entrance of Classical buildings. Although they were usually a feature of major buildings in the 18th and early 19th centuries, smaller versions can be found on more modest buildings. There was no definite form for each period, although pediments (left) were popular in the 18th century and flat topped porticos (right) were more popular in the first half of the 19th century. It tends to be in the details like the type of column and capital (see Chapter 6) which can be clues to dating.*

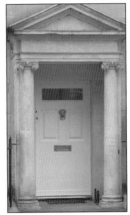
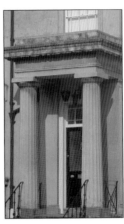

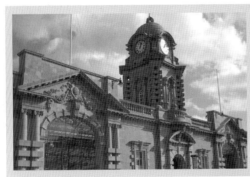

Nottingham Station: *The baroque style of the late 17th and early 18th century, with its muscular and flamboyant decoration, was revived in the early 20th century. The entrances in this example have elliptical arches which are a distinctive Edwardian touch, as the originals were usually semicircular. The eclectic clock tower is also clearly of this period, with its dome displaying an Indian flavour.*

FIG 5.7: Fanlights: *On double pile buildings the hallway leading to the rear rooms was dark so overlights above the door were introduced. Examples from the late 17th and early 18th centuries were rectangular with simple divisions (top left). In the second half of the 18th century semi circular forms became common. Metal enabled delicate patterns to be fitted (top centre and right) while batwings became popular during the Regency period (bottom left). Simple fanlights set in reeded surrounds are distinctive of the early 19th century (bottom centre). The Victorians favoured rectangular and plain fanlights (bottom right).*

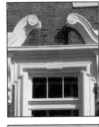
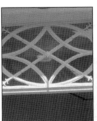
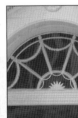

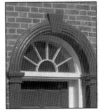

DOORS

FIG 5.8: Plank and batten doors *are simply constructed from vertical planks, held together on the inside by horizontal battens. The earliest tend to have only a few planks of irregular width with long strap hinges and nail heads sometimes formed into patterns (top left). Four planks became more common in the 17th century (top centre). These basic doors are hard to date, but few are earlier than the 16th century and most will show signs of decay, especially at the bottom which would have often been replaced (top right). Better quality doors could have vertical battens covering the gaps, and in the 17th century these would have been arranged to create a panelled effect (bottom left). Plank and batten doors were still fitted to cottages in the 18th*

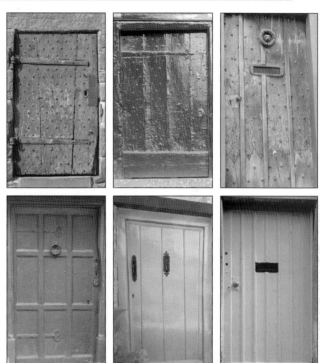

and early 19th centuries, but the planks are regular in width and often with a cock bead down one edge (bottom centre). Victorian doors tend to have narrow machine cut planks with vertical battens and an outer frame fitted around the edge of the door itself (bottom right).

Burton Agnes Hall, Yorkshire: *Gatehouses marked the entrance to the courtyard of important buildings up until the mid 17th century. Although most Medieval and Tudor examples had crenellations and pointed arches, by the late 16th and early 17th century they have less of a defensive appearance, with ogee caps on the towers and round arches. This fine Jacobean gateway also has a coat of arms, flanked by odd sized female statues supporting the entablatures (caryatids) and bases with elongated diamonds (lozenges) - all distinctive features of this period. The gatehouse was designed by Robert Smythson for Sir Henry Griffiths in around 1610.*

FIG 5.9: Panelled doors:
Doors formed from a framework with panels slotted in became fashionable in the late 17th century. Early types tend to be squat to suit the lower door heights of the time, some with glazing in the upper panels where there was no fanlight (top left). Six panels was the standard form during the 18th and first half of the 19th century, earlier ones tend to have similar sized centre and bottom panels (top centre left), later ones usually have taller central panels (top centre right). Regency architects often played with rectangular and circular panels to create unique designs (top right). The four panelled door was common in the second half of the 19th century (bottom left). By the late Victorian period, deeply set panels with

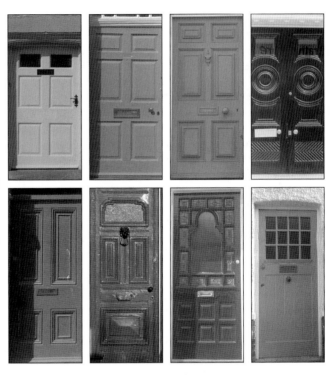

raised edges and curved upper openings were fashionable (bottom centre left). Many Edwardian doors comprised of numerous glazed openings, normally with at least one arched pane (bottom centre right). Doors with the upper third glazed and lower section panelled were introduced in early 20th century and became the standard form by the 1930s (bottom right).

Ashbourne, Derbyshire: This fine Georgian Classical building has a number of features which would indicate that it dates from the mid 18th century. The pedimented portico with Roman Doric columns would suit this date, as would the door with even centre and lower panels. The Venetian window above it and the Diacletian window (semi circular) above this were also fashionable around this time. The other distinctive feature of the 1750s and 60s is the even sided canted (angled) bays, which dominate this symmetrical facade.

COLUMNS, CAPITALS AND DECORATION

How to date the details

Decorative details are shaped by architectural fashions, and on the oldest buildings by local styles. They not only narrow down the construction date, but also reflect the original status of the building. The ambitions of the owner or builder are demonstrated in how elaborate and lavish the carving and decoration is. Care, however, needs to be taken in establishing which details are original, as some could have been added later. The Victorians in particular replicated most older styles, with sometimes deceiving accuracy.

Medieval buildings are blessed with handmade carvings on the capitals on top of columns, parapets around the roof and the surrounds of important doors and windows. This most splendid display of the mason's skills were usually reserved for the west front of large churches, cathedrals and abbeys. Late Medieval and Tudor timber framed buildings used the structural elements themselves for decorative effect, and on the finest examples added carvings to brackets, beams and mouldings.

Decoration continued to be an important way of advertising the status of a building throughout the 17th and early 18th centuries. The Dutch-inspired style was distinguished by decorative brackets under the eaves and

supporting the shell-like hoods over the door. Baroque buildings were notable for their deep and vibrant carving on statues, around entrances and along their busy skyline.

The Palladian and Neo Classical styles which dominated architecture through the 18th and early 19th centuries can be distinguished by their plain unadorned walls. This lack of decoration is in itself useful in dating buildings from this period. This restraint, however,

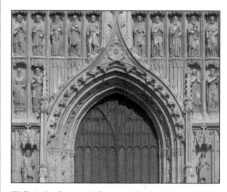

FIG 6.1: Carved figures *featured on the exterior of many major Medieval churches, but were mostly destroyed in the wake of the Reformation. Most statues today are actually Victorian or later, reinserted into the original canopy during restoration with realistically proportioned bodies and faces clearly shaped by 19th century fashion. Statues also became fashionable on public buildings built during the 1860s and 70s.*

was far from universal. Carved details like the shallow and delicate patterns of the Adams style, which was popular from the 1760s to 80s, and decorative ironwork which is distinctive of Regency buildings, embellish these otherwise plain facades.

The Victorians loved decoration and walls became a riot of colour, patterns and carvings. Some of these fashionable details were simply mass produced in factories and applied en mass to satisfy ambitious owners. The embellishment of buildings continued into the early 20th century, although in the Edwardian period the patterns tended to be less elaborate, with white painted wood popular. In the wake of the First World War, decoration was more sparingly used, but a desire for modernity made Art Deco, with its bold geometric patterns reflecting discoveries in Egypt and futuristic designs from Europe and America, a popular choice.

COLUMNS AND CAPITALS

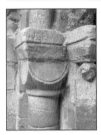 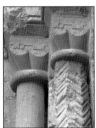 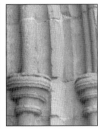 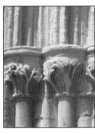

FIG 6.2: Columns and capitals formed part of the decoration around windows and doors on many Medieval buildings, particularly churches. The Normans used simple cushion shaped capitals (left), some with scalloped undersides and zig-zag decoration (centre left). Later Medieval types tended to be either simple in form on thinner shafts (centre), or with stylised foliage (centre right). Elizabethan buildings were influenced by the Renaissance, with a square shaft tapering out towards the top (right) being distinctive of this period.

Sutton Scarsdale, Nottinghamshire: Pediments were usually plain in the 18th century, but earlier types had carving within as in this example on top of the giant Corinthian columns. This evocative ruin retains other Baroque features, with its fully rusticated walls (the horizontal grooved masonry) and parapets, which would have originally had balustrades in the gaps. This front was completed in 1729 but the house was stripped out from 1919 with a number of its interiors now in museums in the USA. The shell was saved in 1946 by Sir Osbert Sitwell and given to the nation in 1970.

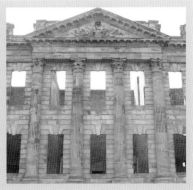

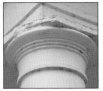
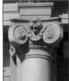
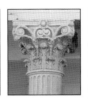

FIG 6.3: Georgian and Regency: *By the early 18th century the proportions of a building were being shaped by the Roman orders, the dimensions and style of the base, column, capital and entablature which fronted their buildings. They are most easily recognised by the form of the capital. The different styles are the Doric (top left) and the similar Tuscan, the Ionic (top centre), and the Corinthian (top right). The Composite combined the Ionic and Corinthian capitals. In the late 18th and early 19th centuries the more basic types found in Ancient Greece became fashionable. Greek Doric (bottom left) had a simple cushion capital, with a broad fluted column, and distinctively with no base, while the Ionic (bottom right) was decorated with a pair of parallel volutes.*

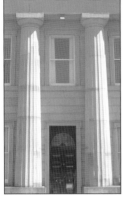
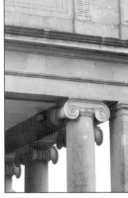

FIG 6.4: Victorian: *By the mid 19th century Medieval foliage capitals mounted on a wide variety of columns became fashionable. The carving is sharper and they often have animals in the design. Polished marble columns and spheres (right) are distinctive of the 1860s and 70s.*

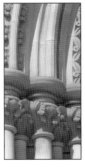
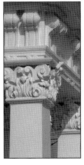
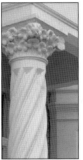
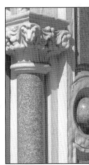

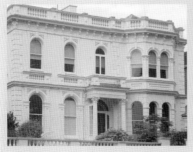

Leamington Spa, Warwickshire: *This suburban building seems like it could have been lifted from a glamorous continental city. Its stuccoed walls, round arched windows with raised surrounds and ornate spandrels, bracketed cornice and parapet with balustrade were designed with a distinct Italian flavour. These decorative details, and the asymmetrical facade with a low pitched tower just out of view, are distinctive of Classical buildings from the mid 19th century.*

WALL CARVINGS AND MOULDINGS

FIG 6.5: Medieval: *Blind arcading with interlocking round arches was distinctive of Norman buildings (top left). Lancet pointed arch arcades were a feature of 13th century churches (top right), along with dog teeth (bottom left). Ball flowers (bottom right) came into favour in the early 14th century.*

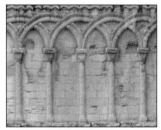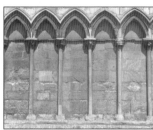
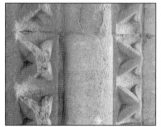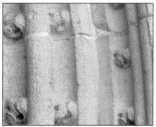

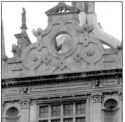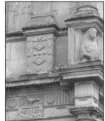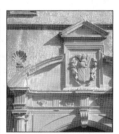

FIG 6.6: Elizabethan and Jacobean: *Patterns formed from interlinked bands known as strapwork were fashionable from the 1580s to the 1620s (left and centre left). Diamond-shaped lozenges, Tudor roses and inaccurate exotic animals (centre right), along with the continued use of coats of arms (right) are also distinctive of this period.*

FIG 6.7: Medieval and Tudor *buildings had hood moulds projecting above individual windows to keep rain out of the opening (left). By the second half of the 17th century, a horizontal string mould across each floor level, along with raised quoins (corner stones) and a deep cornice were fashionable (right). By the mid 18th century, string moulds had fallen from fashion.*

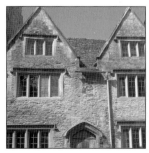

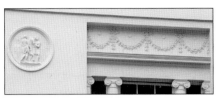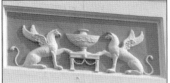

FIG 6.8: Adams and Greek Revival: *Palladian facades avoided decoration, but in the second half of the 18th century some carvings and mouldings could be found on Classical buildings. Delicate and shallow swags and roundels (left) are a key feature of many buildings inspired by Robert Adams in the late 18th century. The revival of Ancient Greek motifs made for popular decorative features in the Regency period (centre and right).*

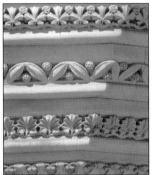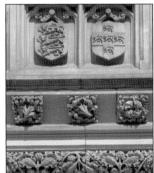

FIG 6.9: Victorian Gothic: *The revival of Medieval Gothic forms combined with the Victorians' love of decoration resulted in buildings from the late 1850s through to the 1870s being covered in a rich garnish of foliage, coats of arms, and beasts. Although elements are stylised, most are more finely carved with accurate detailing and have a greater depth than the more weathered originals.*

FIG 6.10: Terracotta decorative plaques and tiles *became fashionable in the last decades of the 19th century. Earlier ones tend to be unglazed red terracotta, with sunflowers being a popular motif (left and centre left). Glazed cream terracotta which was resistant to pollution was fashionable in the 1890s and early 1900s, often featuring heart shapes (centre right) and Art Nouveau designs (right).*

FIG 6.11: Patterned ceramic tiles *were used on the exterior flanking doors or set in panels and bands across the facade in the late 19th and early 20th centuries. Earlier tiles tend to combine printed or embossed designs, often featuring flowers and Medieval designs surrounded by plain geometric tiles (top left and right). By the late 1890s, glazed tiles with embossed sinuous plants and other Art Nouveau designs were popular (bottom left). Colourful mosaics can be found on some Edwardian buildings (bottom right).*

FIG 6.12: Early 20th century carving *featuring flamboyant festoons, swags and cherubs (left) were a feature of the revival of late 17th century Baroque in the Edwardian period. After the First World War, Art Deco designs with zig-zags and stylised geometric patterns (centre left and right) were popular on major buildings. The public's enthusiasm for this style derived from the archaeological treasures being discovered in Egypt during this period (right). By the 1930s surface decoration became more limited.*

Ludlow, Shropshire: *The segmental arched sash windows with prominent keystones, the rusticated quoins and the roof hidden behind a parapet all point to this being an early Georgian house. The matching pair of metal decorated rainwater traps and down pipes proudly mounted down each side of the facade are distinctive of the early 18th century. The casting on the traps records the date as 1728, which fits the overall structure and style of this house. Although the sashes in the window frames and the door are later replacements, the building is otherwise little changed.*

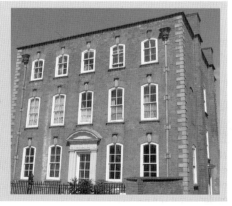

METALWORK

FIG 6.13: Rainwater traps: *As soon as parapets and deep cornices came into fashion in the late 17th century, so metal guttering to direct rainwater away from the roof became desirable. In the first half of the 18th century, elaborate rainwater metal traps with Classical motifs (left and centre left) were a feature of the facade. The down pipe was held in place by broad lead straps. Once the novelty had worn off, metal guttering was made as discrete as possible with plain cast iron pieces used throughout the 19th century. Occasionally, more elaborate designs were cast on Gothic revival (centre right) and Arts and Crafts style buildings (right), often with foliage patterns and crenellations decorating the traps.*

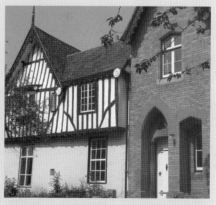

FIG 6.14: Balconies and porches *in the first half of the 19th century had distinctive ironwork. Greek Revival motifs were also popular during the Regency period.*

Sleaford, Lincolnshire: *Some old buildings are a jigsaw of elements from many different periods. This vicarage has a 15th century timber frame with 18th century windows fitted below, and a Victorian gothic brick extension added to the right in 1861.*

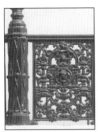 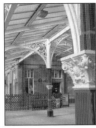 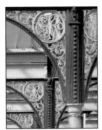 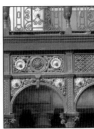

FIG 6.15: Victorian cast iron *railings, columns and brackets in the second half of the 19th century tend to be heavier and more elaborate in design than earlier Regency examples. Classical and Gothic motifs were used, although not always on buildings of a similar style. By the end of the 19th century, designs simplified with Arts and Crafts and Art Nouveau designs (right) featuring sinuous plants and heart motifs are distinctive of the age.*

FIG 6.16: Original iron railings *only had one horizontal bar along the top, with the bottom set in a stone base (left and centre left). Modern replacements usually have a bar top and bottom. Art Nouveau designs (centre right) were popular in the Edwardian period, and Art Deco (right) in the 1930s.*

FIG 6.17: Balconies *were very fashionable in the late 18th and early 19th century, when watching people promenading by seems to have been as popular as watching TV is today. Regency buildings, in particular, are notable for their cast iron balconies, with delicate patterned railings and pagoda shaped hoods (left). They fell from fashion in the second half of the 19th century, as privacy became more important. White painted timber balconies built onto the upper floor can be seen on some Edwardian houses (right).*

58

FIG 6.18: Cupolas, *domed and painted white, capped the roofs of late 17th and early 18th century Dutch style buildings (left). These decorative features also provided light and ventilation into the building. Inevitably, they were also adopted by the Victorians and were adapted into the Queen Anne style of the 1870s and 80s (right).*

FIG 6.19: Dutch gables *were a distinctive feature on buildings in eastern and southern counties during the 17th century. They can be distinguished from later ones by their rustic brickwork and relatively plain form. Dutch gables were revived in the late 1870s and remained fashionable throughout the next few decades. Victorian gables tend to be more elaborate with sharp edged brick and terracotta mouldings and plaques (right).*

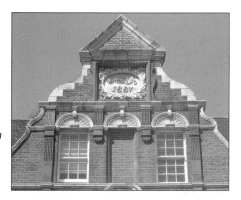

 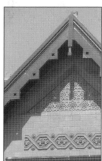

FIG 6.20: Bargeboards *have been added to cover the ends of roof timbers and along the edge of gables for centuries, but the Victorians became rather obsessed with them. They applied bargeboards not only to new Gothic style buildings, but also added them to old existing structures, which can be confusing when trying to date them. Most bargeboards from the 1850s and 60s are very decorative with deep and hollow carving (left and centre left). During the late 19th century they gradually became less ornate (centre right and right).*

FIG 6.21: **Cornices** *on Dutch inspired buildings from the 17th century had deep overhanging eaves with richly decorative brackets (left). Queen Anne style examples could feature concave coving with pargeting styled decoration (right).*

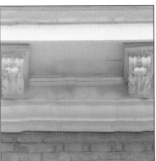

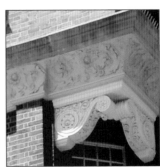

FIG 6.22: **The Victorians** *pioneered the use of iron and glass to form canopies to cover railway station platforms and the entrances to large buildings. Later types were less ornate, but Art Nouveau designs from the early 20th century (top) and Art Deco canopies from the 1920s and 30s (bottom) can be distinguished by their daring form rather than decorative detail.*

FIG 6.23: **Dates** *carved in stone, moulded in brick or cast on ironwork might seem to reveal the date a building was constructed. However, care should be taken as many Georgian date stones mark the time when an older building was upgraded in the latest fashion. Also, the numbers might refer to an early date found on a document, rather than the present building on the site. Date stones on most Victorian and Edwardian buildings, when it was fashionable to record the construction date, are generally accurate. Another clue are the names on streets, rows of terraces or individual buildings, which can sometimes relate to a dateable event. 'Coronation' or a monarch's name can refer to the date when they ascended the throne. Victory in a certain battle or war was also commonly celebrated. This example from a terrace in Beverley, Yorkshire, implies that the row was built when the railway arrived in town, a fact confirmed by the date on the keystone which records the year after the local line was opened.*

GLOSSARY

Adams Style: An influential style of building and decoration devised by Robert Adams. It was popular throughout the late 18th century with distinctive elegant and delicate draping forms and urns based upon finds from Ancient Greece.

Aisle: A side space running along a hall and separated by a row of posts or columns.

Apse: A semi circular or polygonal area at one end of a building, usually a church.

Arcade: A row of arches and columns.

Architrave: The lowest part of the entablature and the moulded surround of a doorway or window.

Art Deco: A number of styles which were popular in the 1920s and 30s but are today regarded as one. One form was inspired by Ancient Egypt with rich decoration and the use of exotic woods and bronze while the other embraced modernism and speed with plain curving walls, intersecting blocks, long metal framed windows and the use of concrete and chrome.

Art Nouveau: A new style which developed in the 1890s inspired by nature with undulating forms and frequent use of flowers, plants and female figures with flowing hair. Limited in this country to interior fittings and window glazing.

Ashlar: Blocks of smooth stone masonry with fine joints.

Balustrade: A row of decorated uprights (balusters) with a rail along the top.

Baroque: A form of Classical architecture with characteristic rich decoration, bold curved forms and lively roof lines which was fashionable in the late 17th and early 18th century.

Blind arcade: A balustrade or series of arches where the openings are filled in.

Bonding: The way bricks, the headers (short end of a brick) and stretchers (long side of a brick) are arranged in a wall.

Bow window: A projecting window which is bow-shaped in plan.

Capital: The decorated top of a column.

Caryatids: Female figures supporting an entablature.

Casement: A window which is hinged at the side.

Castellated: A battlemented feature.

Classical: Architecture based upon the principals and rules embodied in the buildings of Ancient Rome and Greece.

Colonnade: A row of columns supporting an entablature.

Cornice: The top section of entablature which also features around the top of some exterior walls.

Console: An ornamental bracket.

Cupola: A small domed round or polygonal tower which stands on top of a roof or dome.

Dormer window: An upright window set in the angle of the roof.

Double pile: A house which is two rooms deep.

Dutch style: A fashion imported from the Low Countries during the late 17th century with characteristic tiled roofs featuring white dormer windows, a deep cornice and in some cases railings and a cupola on the top. Richly carved hoods or pediments were also fitted above the door.

Eaves: The roof overhang projecting over the wall.

Edwardian: Styles of architecture from the reign of King Edward VII from 1901-1910. It is essentially the last phase of Victorian architecture with Arts and Crafts and a revival of Baroque the most distinctive forms.

Entablature: The horizontal feature supported by columns in a Classical building.

Fanlight: A rectangular or arched window above a front door.

Fluting: Vertical concave grooves running up a column or pilaster.

Frieze: The central band of the entablature and a decorative band across the facade.

Gable: The triangular shaped top of an end wall between the slopes of a roof.

Gabled/pitched roof: A roof with a slope on opposite sides with walls at each end (gables).

Gothic revival: The revival of medieval forms of buildings using pointed arches and asymmetrical planning from the 1750s but which reached a height of fashion in the 1850s and 60s.

Hipped roof: A roof with a slope on all four sides.

Jambs: The sides of a door or window opening.

Keystone: The top, centre stone of an arch which can be projected out as a feature.

Lintel: A horizontal beam which is fitted above a doorway or window.

Louvre: A slatted opening for ventilation.

Mansard roof: A roof with a steep sided lower section and low pitched top part.

Moulding: A plain or decorative strip raised above the wall surface.

Mullion: The vertical bars of a window.

Neo Classical: A bold and severe form of Classical architecture which developed in the late 18th century with an emphasis upon structural form and little if any decoration.

Orders: The different styles and proportions of the plinth, column and entablature from Classical architecture.

Palladian: A Classical style popular in the mid 18th century which was based upon the designs of the 16th century Italian architect Andrea Palladio. These buildings tend to be more refined and plain compared to the Baroque which preceded it.

Parapet: A low wall running along the edge of the roof above the main wall.

Pediment: A low pitched triangular feature on the top of a portico, doorway or wall.

Portico: A porch with a flat entablature or triangular pediment supported on columns.

Plinth: The projecting base of a wall or the block on which a column stands.

Queen Anne: A revival of late 17th century brick buildings which was fashionable in the 1880s and 90s. Dutch gables, elaborate brickwork, terracotta mouldings and white painted windows were distinctive of the style.

Quoins: Dressed or raised stones at the corner of buildings.

Reeding: Strips of convex beading set parallel to each other, usually on an architrave.

Regency: Late Georgian styles of architecture from roughly 1790-1830, although the Prince Regent only reigned as such from 1811-20.

Renaissance: The rebirth of Classical forms of art and architecture from Ancient Rome.

Robert Adam (1728-92): Scottish architect who along with his brother James developed their distinctive Adams style with delicate Classical motifs. His extensive list of buildings of which Kedleston Hall, Derby, is perhaps the finest surviving example, were notable as he was one of the first to design not only the structure but also the furniture and fittings.

Rustication: The cutting of masonry or stucco into lines or blocks separated by deep grooves.

Sash window: A window with two framed sashes, one or both of which slide vertically.

Segmental arch: A bow shaped arch which is formed from a segment of a larger arch.

Sill/cill: The horizontal beam at the bottom of a window or door.

Stucco: A smooth plaster rendering which imitated fine cut stone.

Tracery: The glazing bars of a window which are formed into patterns.

Transom: The horizontal bars of a window.

Vault: An arched ceiling formed from brick or stone.

Venetian windows: A window in three vertical sections, the centre one being arched.

Yorkshire Sash: A small sash window which slides horizontally without pulleys.

INDEX

OTHER TITLES FROM COUNTRYSIDE BOOKS

To see the full range of Trevor's books then visit
www.countrysidebooks.co.uk or **www.trevoryorke.co.uk**

 Follow Trevor on **Facebook** at **trevor-yorke-author**